ISLAND STORY

A true story of
a never-ending summer

Ayumu Takahashi

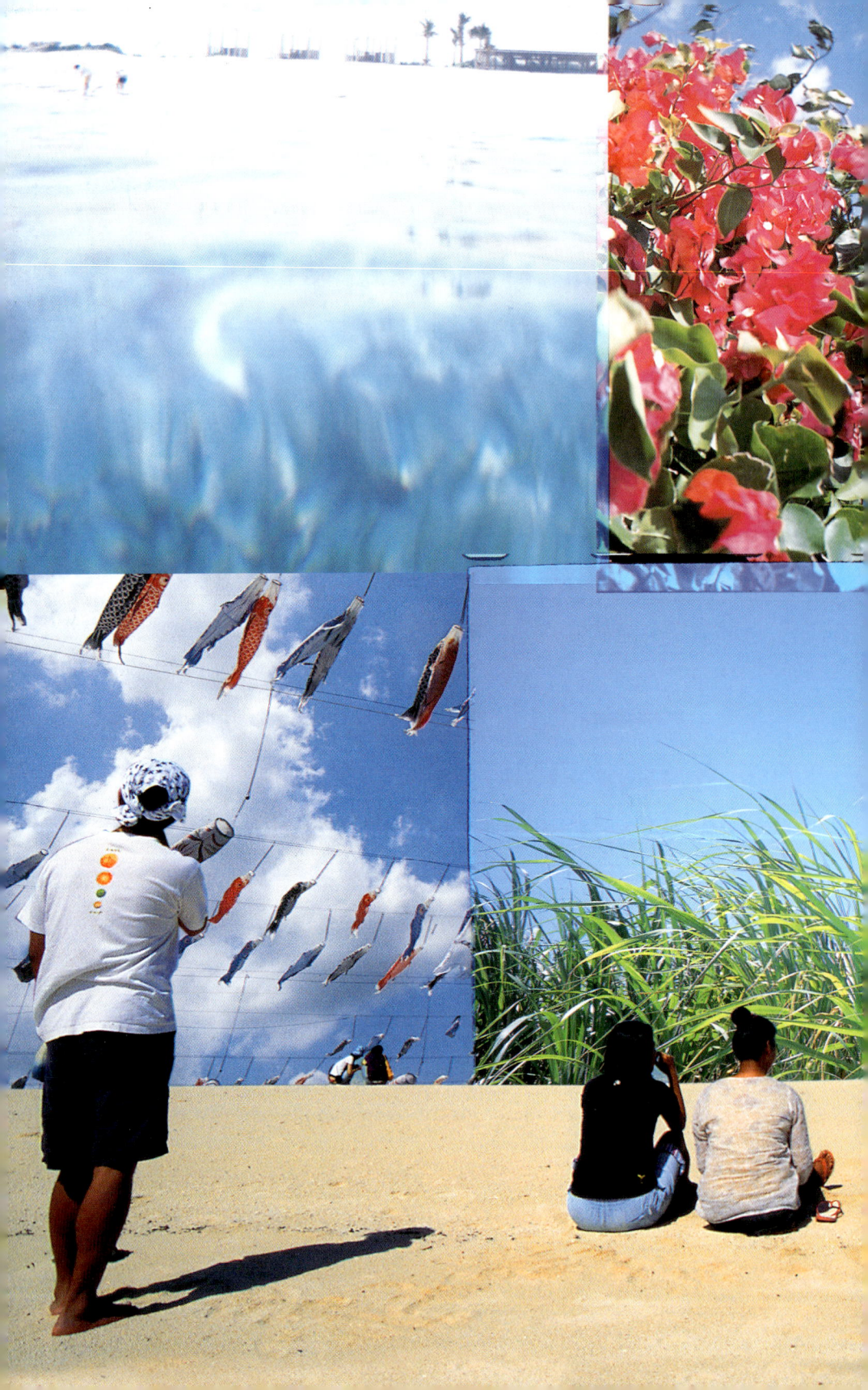

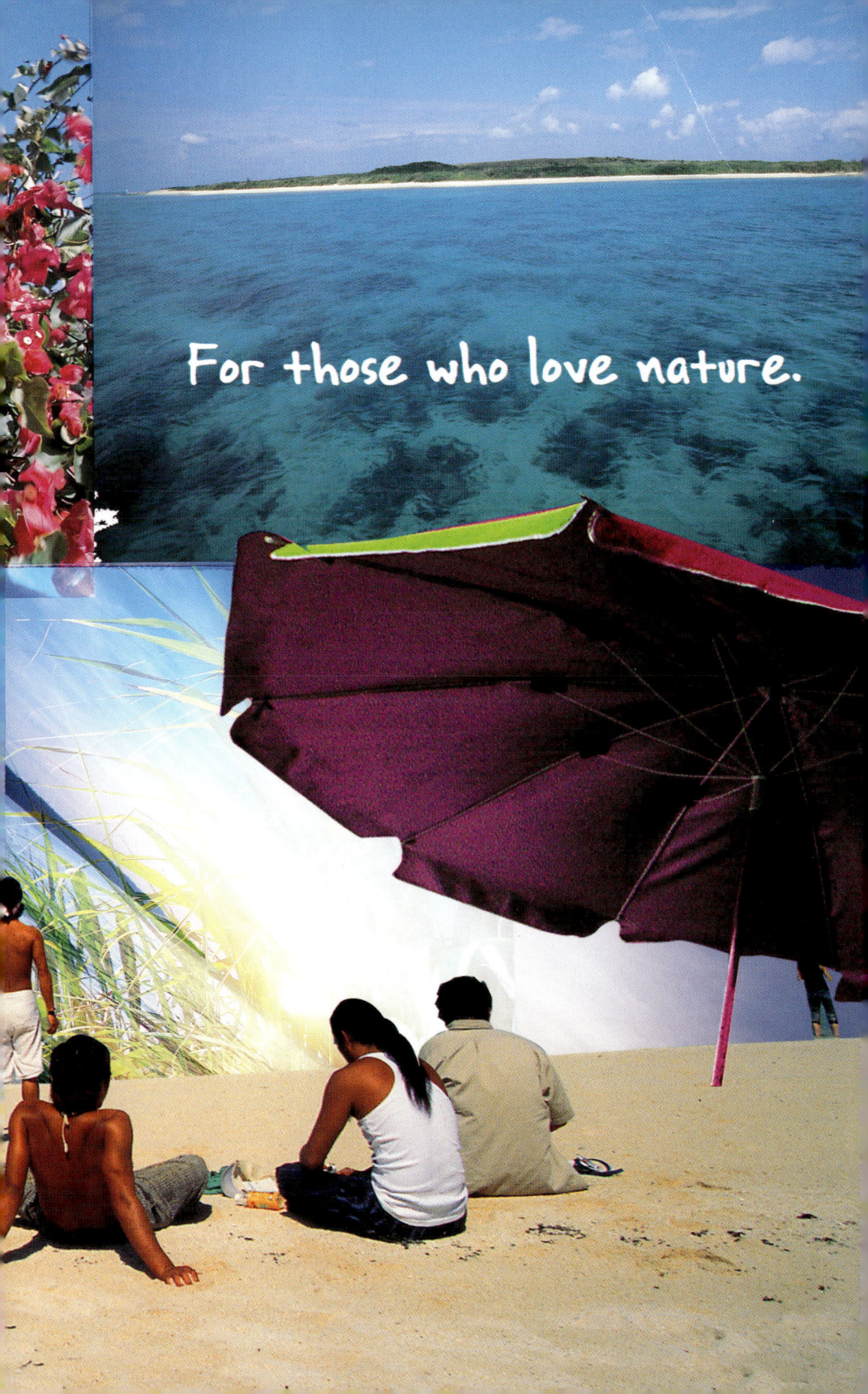

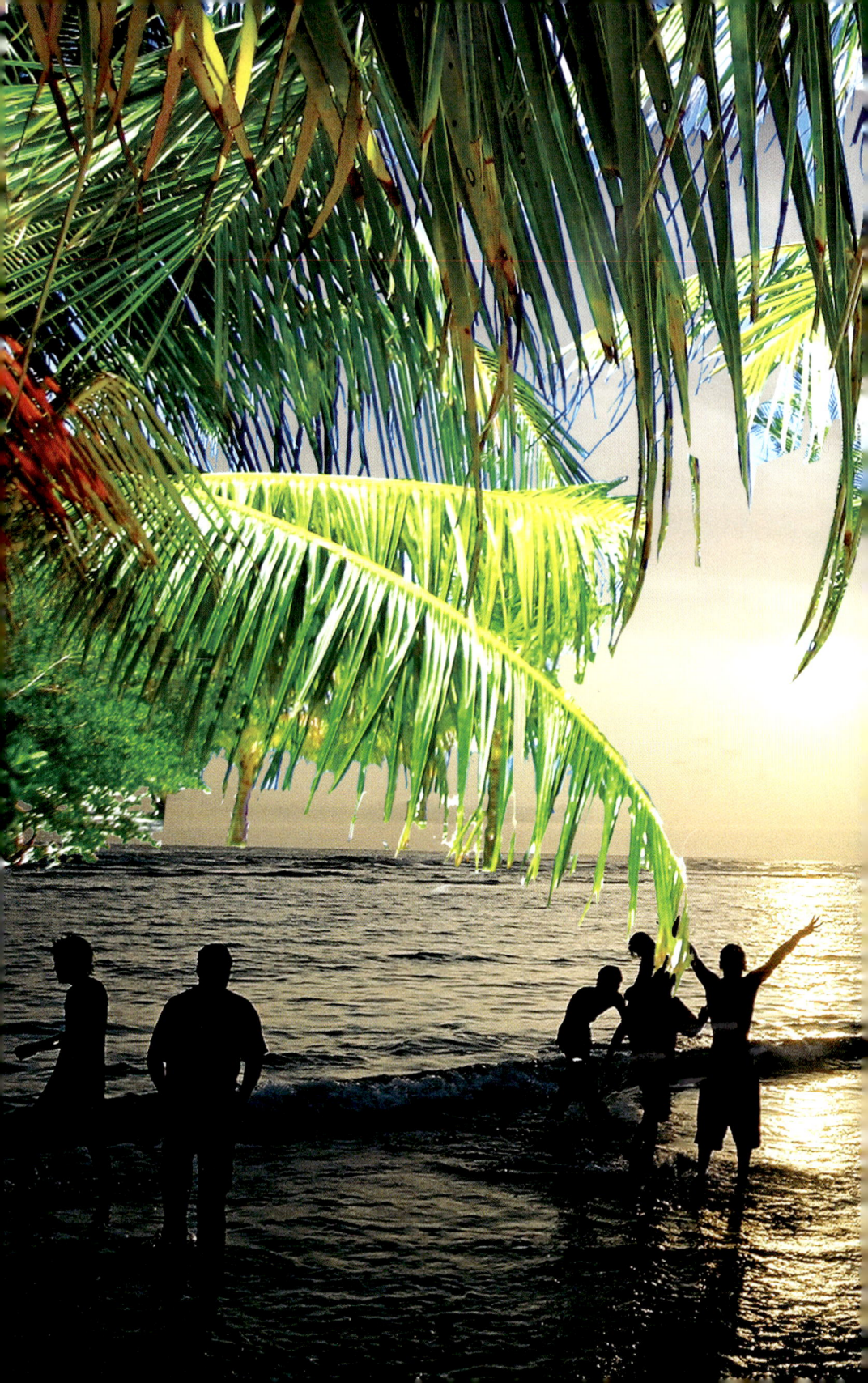

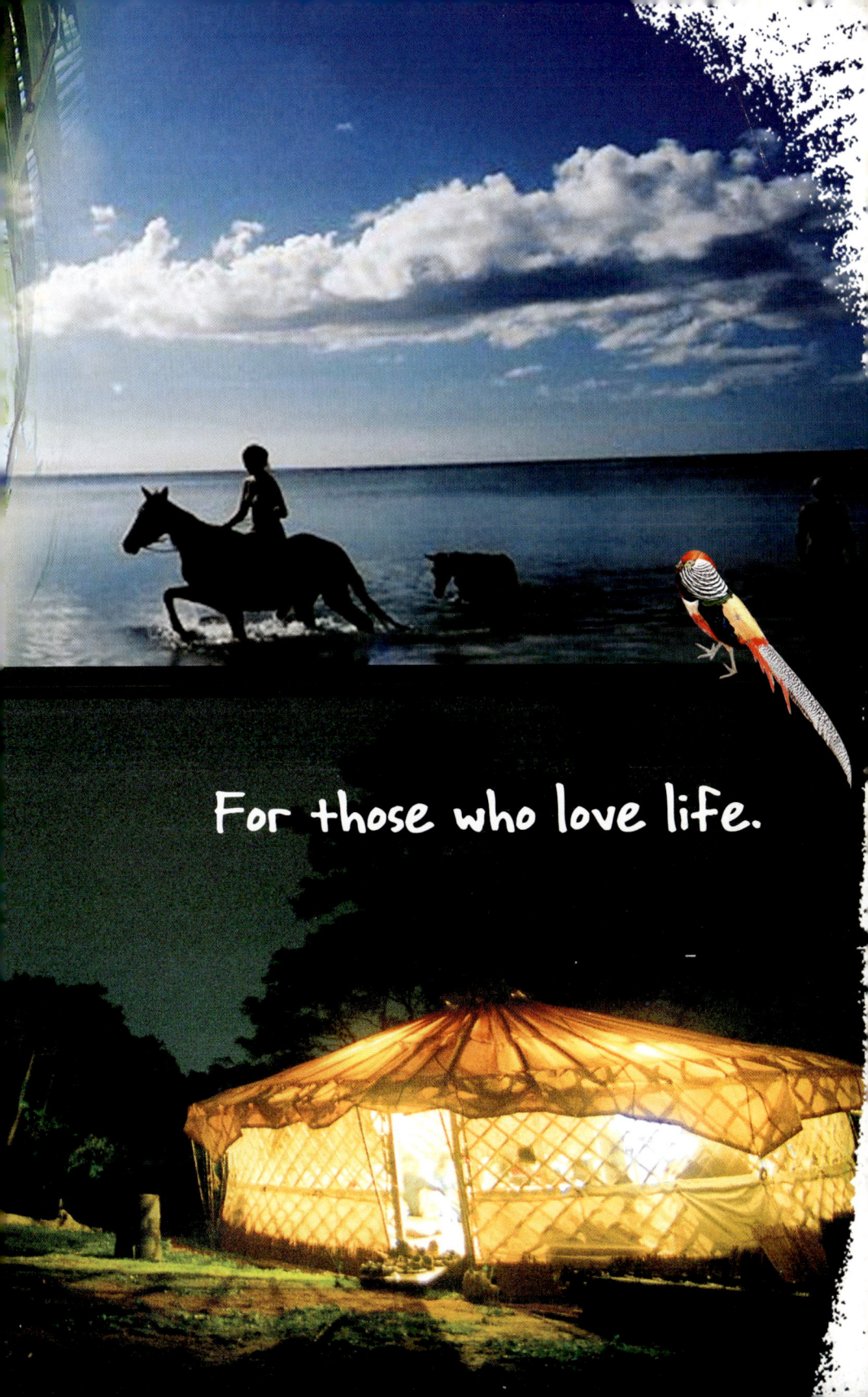

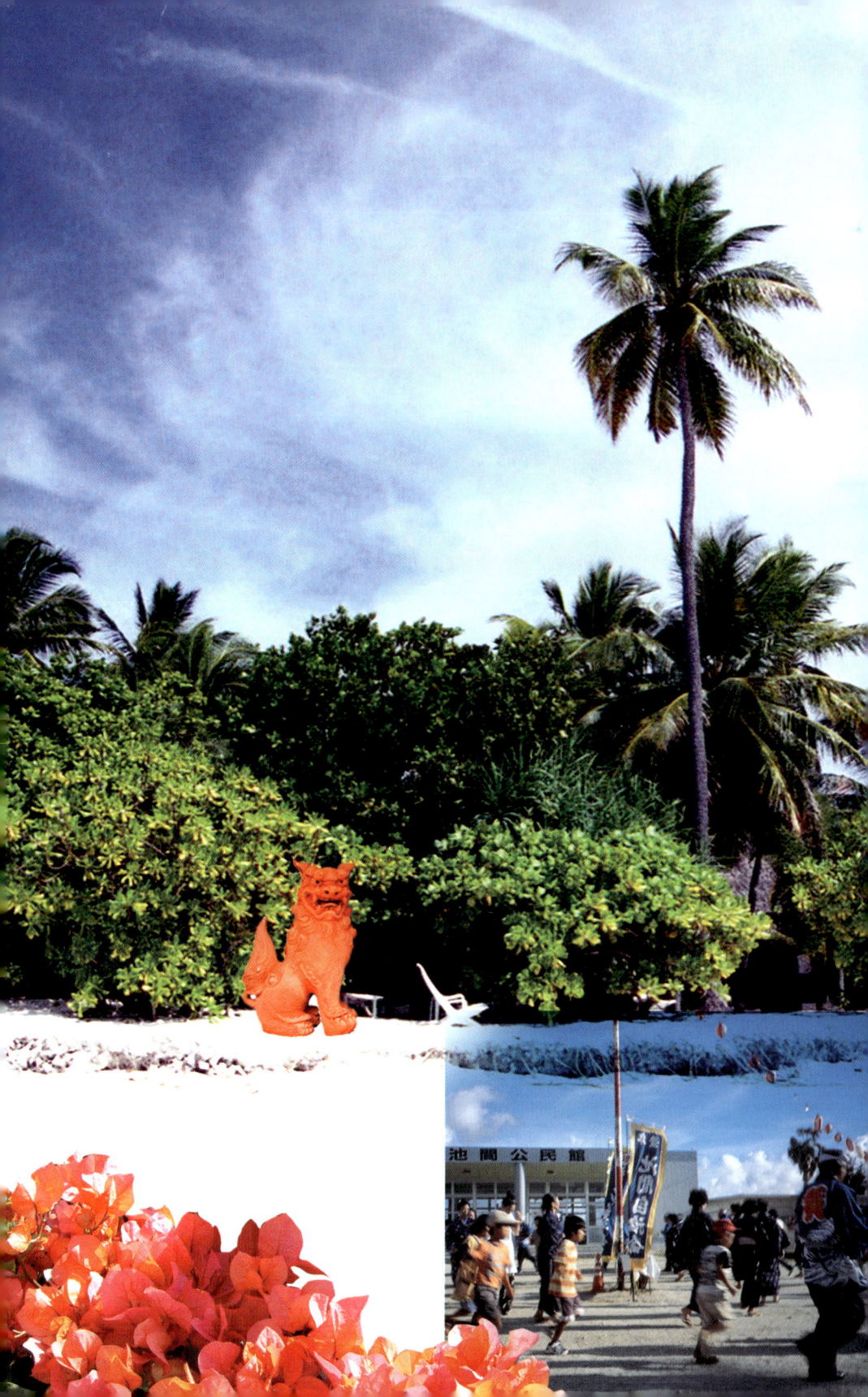

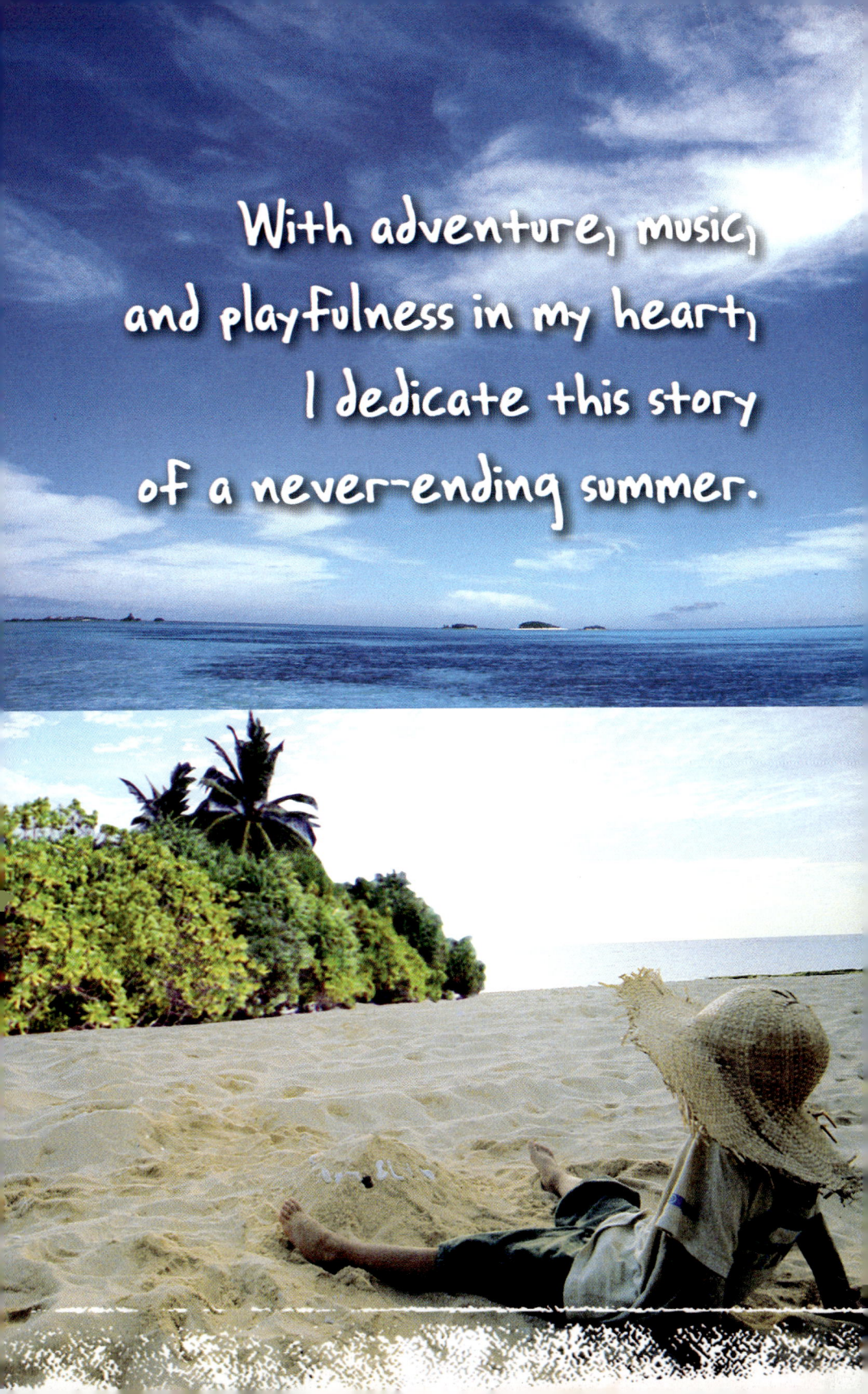

With adventure, music, and playfulness in my heart, I dedicate this story of a never-ending summer.

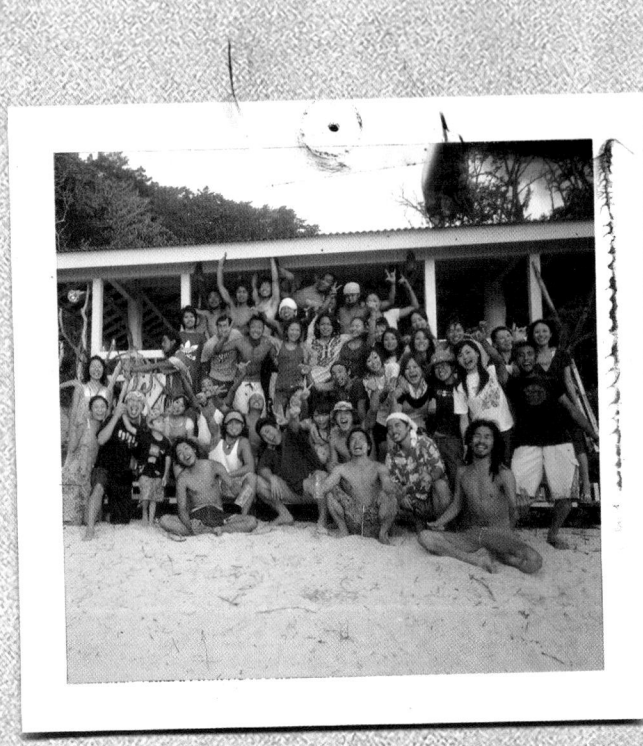

To the friends that
never gave in, and
to the gentle breeze
of Okinawa,
with love.

ISLAND STORY: A True Tale of a Never-ending Summer
Copyright © Ayumu Takahashi
ALL RIGHTS RESERVED
No part of this book may be reproduced or transmitted in any form or by any means, electronic or mechanical, including photocopying, recording, or by any information storage and retrieval system, without the written permission of the publisher. For information, contact One Peace Books, Inc.

Text . AYUMU TAKAHASHI
DESIGNERS MINORU TAKAHASHI, ANNE LOCASCIO
EDITOR YOUHEI TAKIMOTO
TRANSLATOR MICHELLE DOSTER
DESIGN ASSISTANT YUKO OTSU
ASSISTANT TAEKO MORIKI, TOSHIAKI TOKUNAGA, RYO IJICHI
TREASURER AKIRA NIHEI
PHOTOS KEISHI OISHI, HIRONORI NAKAGAWA
MAP ILLUSTRATION YUKO OTSU (pg. 136–137/pg183),
　　　　　　　　　　　　　　IKUKO NISHIMURA (pg.183)
　　　　　　　　　　　　　　© iStockphoto.com / RichVintage, Chictype, Ayzek, Macroworld

Published by
ONE PEACE BOOKS, INC.
57 GREAT JONES STREET
NEW YORK, NY 10012 USA
TEL 212-260-4400
FAX 212-995-2969
www.onepeacebooks.com

PRINTED IN Canada

Every effort has been made to accurately present the information presented herein. The publisher and authors regret any unintentional inaccuracies or omissions, and do not assume responsibility for the accuracy of the information in this book. Neither the publisher nor the artists and author of the information presented herein shall be liable for any loss of profit or any other commercial damages, including but not limited to special, incidental, consequential, or other damages. Corrections to this work should be forwarded to the publisher for consideration upon the next printing.

Contents

Prologue — 13

1: Dream & Money — 23

2: Friends & Hideout — 43

3: Ocean & Sky — 69

4: Dead or Alive — 79

5: Heaven & Hell — 91

6: Love & Hate — 109

7: Image & Action — 131

8: Zero to One — 167

9: Hello & Goodbye — 205

Epilogue — 237

Note from the Author — 250

Prologue

With the 21st century rising before us, my wife, Sayaka, and I returned to Japan in the summer of 2000. We had just completed a low-budget, two-year-journey-around-the-world honeymoon.

Ahh…Japan is as heartwarming as ever.

Egg rice is seriously the best.
I could eat it every day.

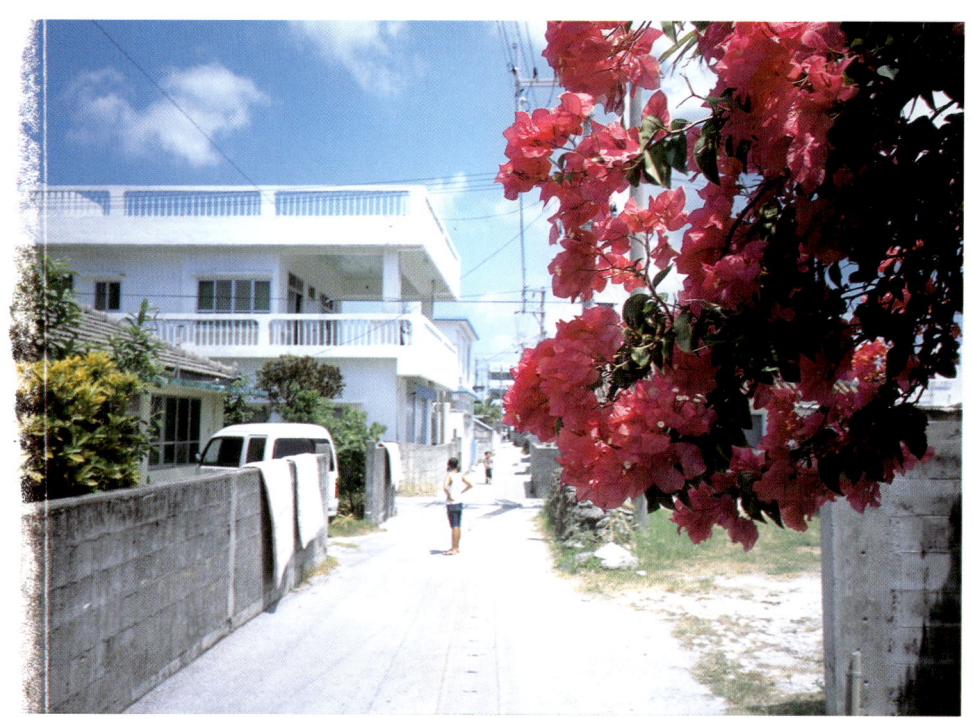

For a while, we were relaxing at my parents' house in Yokohama. We had canceled the lease on our apartment prior to departing on our journey, so we needed to find a new home.

Hey, where should we live?

What should I do for work?

I don't know yet, but somehow I'm not feeling like living in Tokyo, y'know?

*Well, for the time being, why don't we think about it
while traveling around Japan?*

We put on our backpacks again and began roaming around Japan—going any direction our hearts desired.

I like the warmth better than the cold.

Prompted by that one comment from Sayaka, we headed south. Several months later on our journey in search of a new home, we drifted into Okinawa. We fell in love in an instant.

We gotta live here, right?
It's final! Yay!

People often asked, "Why Okinawa? What do you like about Okinawa?" Frankly, I couldn't come up with any particular reason. My brain just sparked...I just believed in my goose bumps. Actions don't always need a reason.

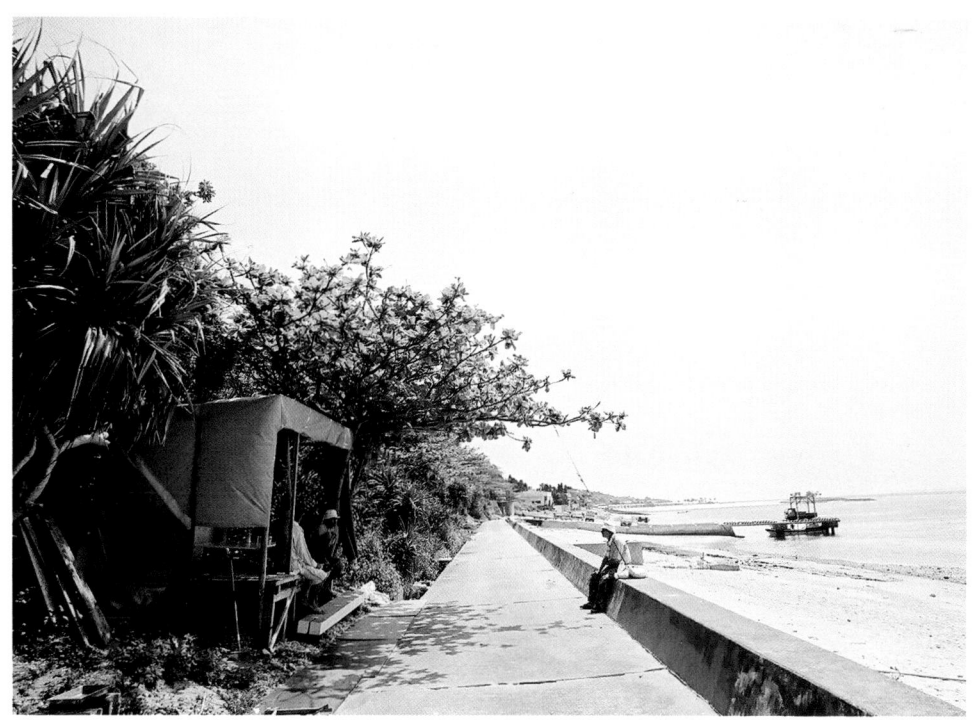

Riding through Chatan on Route 58, with Sayaka on the back of the motorcycle, a realtor's office appeared in front of us..

I hit the left-turn signal and pulled in.

They had a beautiful beachfront house available.

I signed the lease right then and there.

Island Story 17

Since we had used up our money on our journey, we only had about twenty thousand yen.

We went to a local loan company and took out a loan to help us get started.

In Japan, borrowing a few hundred thousand yen is not a problem. Any adult male, no matter what he does, can at least make a ten-thousand-yen-per-month payment. Being able to borrow money that you can return is a beautiful thing!

Just like that, our emigration to Okinawa was successfully completed.

We spent those early days lounging around in our newly rented, empty house; drifting around on our recently purchased, worn-out motorcycle; and getting happily drunk on the island liquor, awamori. We were a young, unemployed couple, slowly adjusting to the vibe of this island.

And, in beloved Okinawa…VIVA! NEW CENTURY!

We celebrated the beginning of a happy 21st century.

Nothing changed about daily life in Okinawa, even with the coming of the 21st century. We burst out laughing at the island TV reporter who, with a serious face, was making comments like, "It's very cold today. The temperature has dropped below 70 degrees."

For a while, I entrusted myself to the warm winter of Okinawa and vegged out. The two of us were engulfed in the big ocean and sky. We spent our days discussing the difference between Okinawa soba and sōki soba noodles, and dropping fishing lines into the river by our house. Over time, Sayaka and I were slowly drawing a map of our plan for the future.

Island Story 21

Chapter 1: Dream & Money

The money from the loan company started to run out.

I guess I'd better start working soon, since we don't have any money.

But, what do I want to do?

There's nothing in particular that I want to do…

Well, I guess for now I could do some day labor.

The local supermarket, Sanei, was looking for part-timers.
It would be a drag and a hassle; but with no money, there was not much of a choice.

I sat thinking about working at the supermarket, staring at the ocean, and listening to my favorite Okinawa music on my Walkman. I was bouncing around ideas about future work, when suddenly I regained full consciousness. The primary colors of the Okinawa winds pulled me back to my origin.

Hmm. Hold on!

We're already living here in Okinawa, with all these beautiful islands.

It seems like there's gotta be work that's a little more interesting?

Hmm, islands…Something feels right.

We saw a lot of islands on our world journey. On a quiet island, surrounded by beautiful beaches and mountains, together with friends that share the same vision, we could be self-sufficient. We could run an inn, a shop, have creative activities, and live in nature, surrounded by music and art. We only needed enough money to get by. Getting by does not take much if every day is filled with words and phrases like "Delicious!" "Fun!" and "Feels Great!"

That'd be nice—that kind of island life…

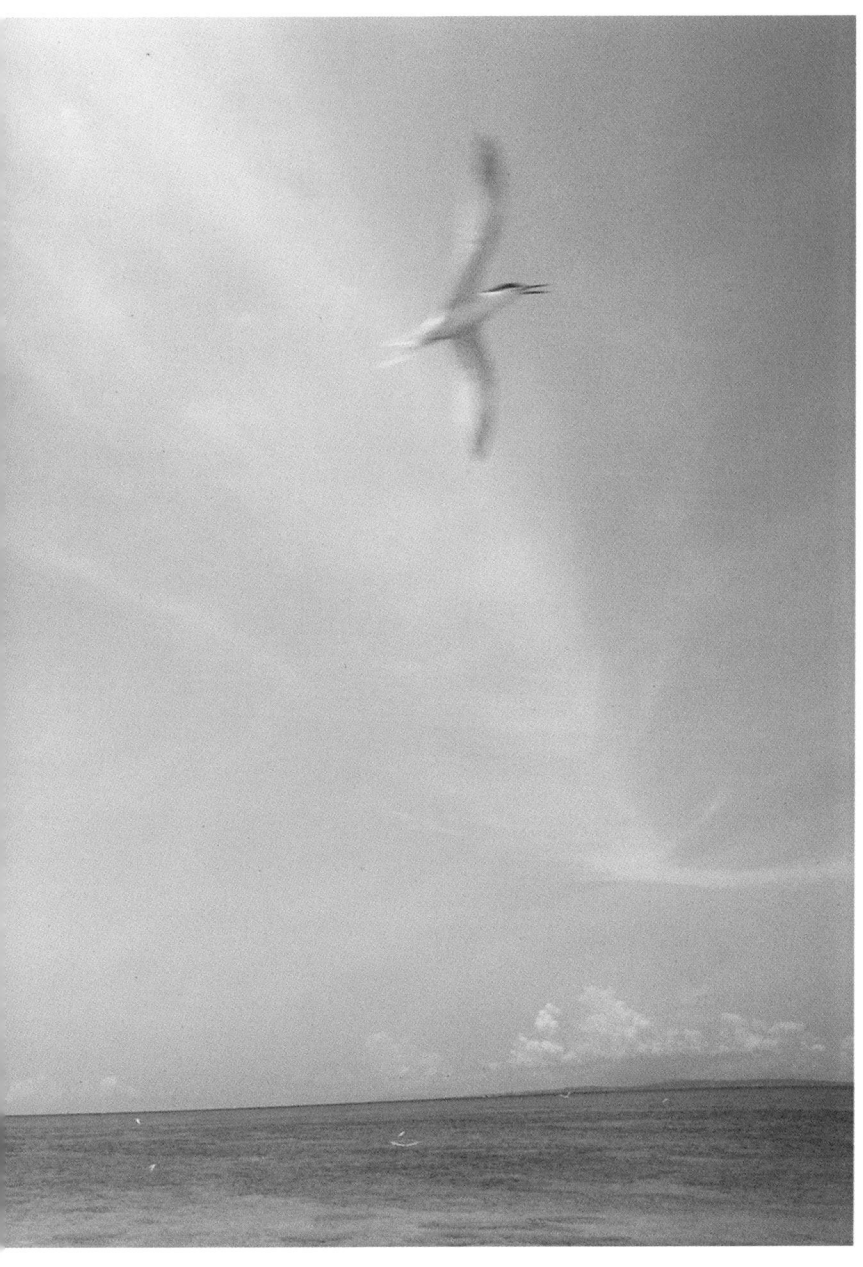

Island Story 27

Yeah. This is it!

This is what I should do now!

I should've realized sooner!

On one of the islands here in Okinawa, we could rent some cheap land, make lots of friends, and put everyone's energy together. It would be seriously fun to build a paradise from *nothing*. We could make all the buildings by hand and grow all our food; that way, it wouldn't cost all that much. It would be a place where good music was always playing and a nice breeze was always blowing.

Why not build a self-sufficient village overflowing with music and art?

That is too cool.

This is it!

Seriously, let's do it!

Once I got the idea, I couldn't be stopped. No matter what I was doing, what I was seeing, it was all I could think about. The springs of imagination were overflowing, and my fantasy world kept widening. Grinning to myself, I suddenly started scribbling my overabundant thoughts into my Pikachu notebook.

OKINAWA ISLAND PROJECT
IMAGE NOTE

Ayumu Takahashi

on some island in my favorite Okinawa,
rent some cheap property,

we, ourselves, are self-sufficient in everything;
food, clothing, shelter, + energy,

run a guesthouse / café / restaurant / bar / live house / theater, etc.

start a brand: sell clothing, accessories, and household goods made in the island studio,

sponsor Island Trip Tours devoted to enjoying the islands of Okinawa,

start a school to teach how to live freely,

have thrilling festivals...

a place with the big ocean and under the big sky.

surrounded by the best music, the best liquor, and the best friends.

Let's live a life of survival
and a festival!

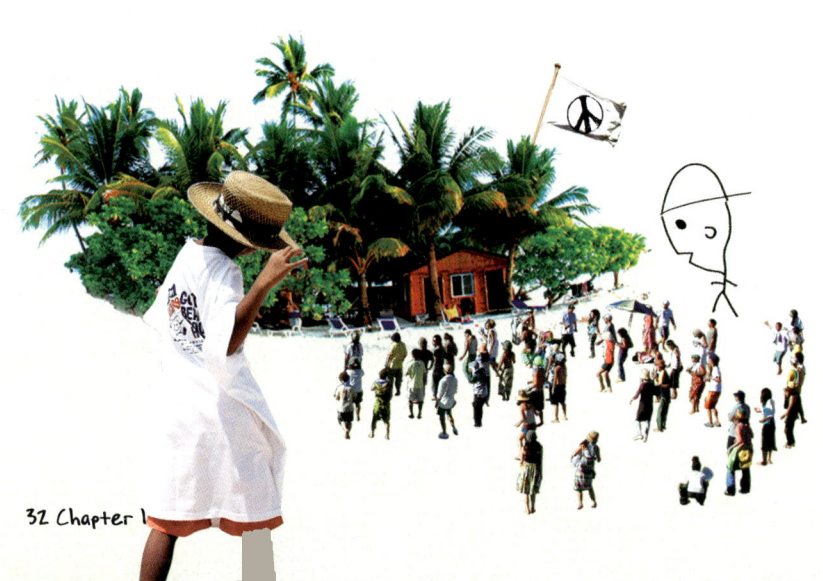

32 Chapter 1

a huge toy box where adults can play,

a rainbow-colored atelier where it rains inspiration,

under the blue sky, with liquor and music in hand, a salon
where everyone can meet as equals,

treasure island, pirates, secret fort, submarine ruins, legends of mermaids...
Tom Sawyer, Disney, Laputa, Nausicaä, One Piece...

Let's make such a dreamland a reality!

Island Story 33

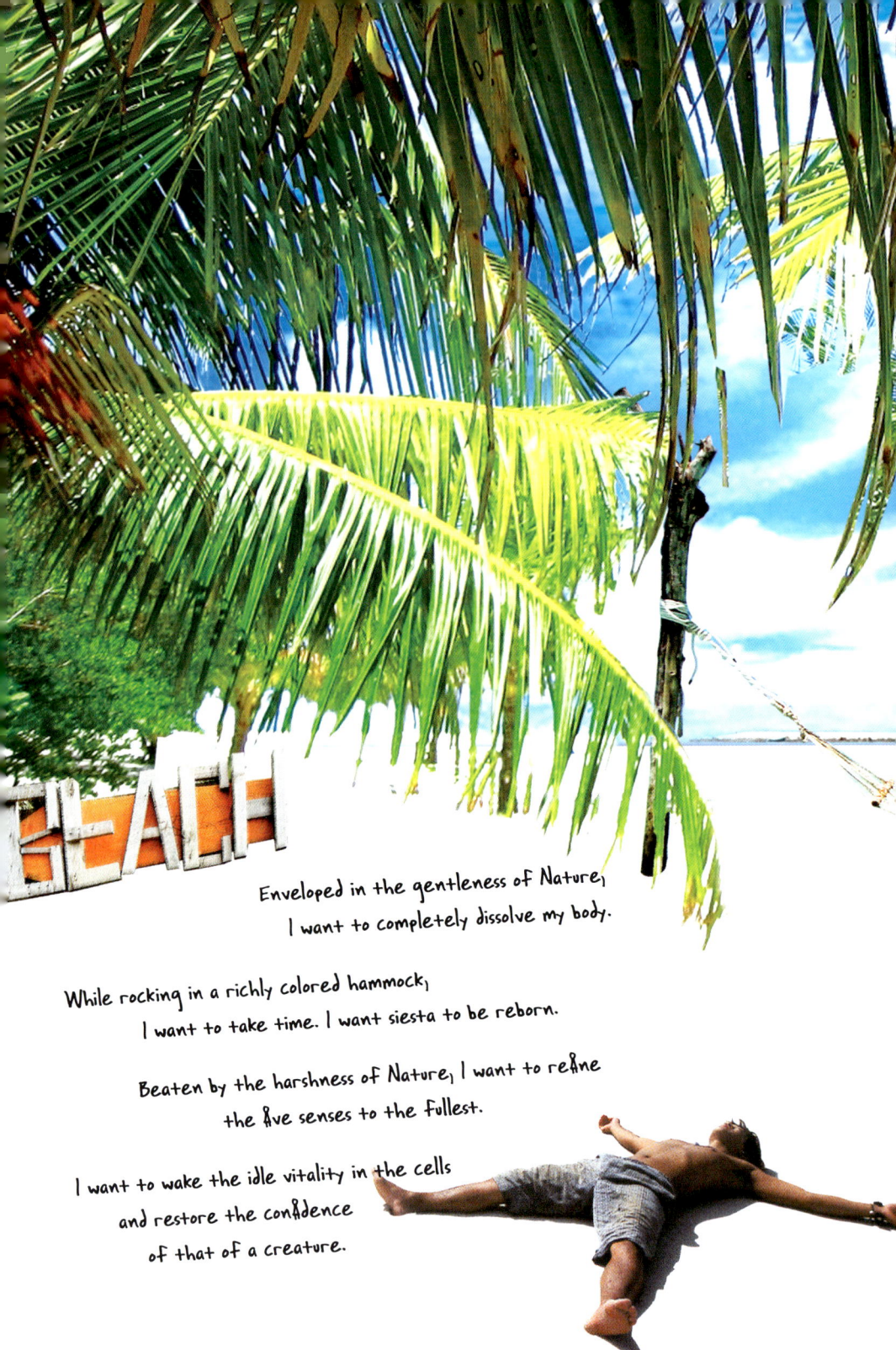

Enveloped in the gentleness of Nature,
I want to completely dissolve my body.

While rocking in a richly colored hammock,
I want to take time. I want siesta to be reborn.

Beaten by the harshness of Nature, I want to refine
the five senses to the fullest.

I want to wake the idle vitality in the cells
and restore the confidence
of that of a creature.

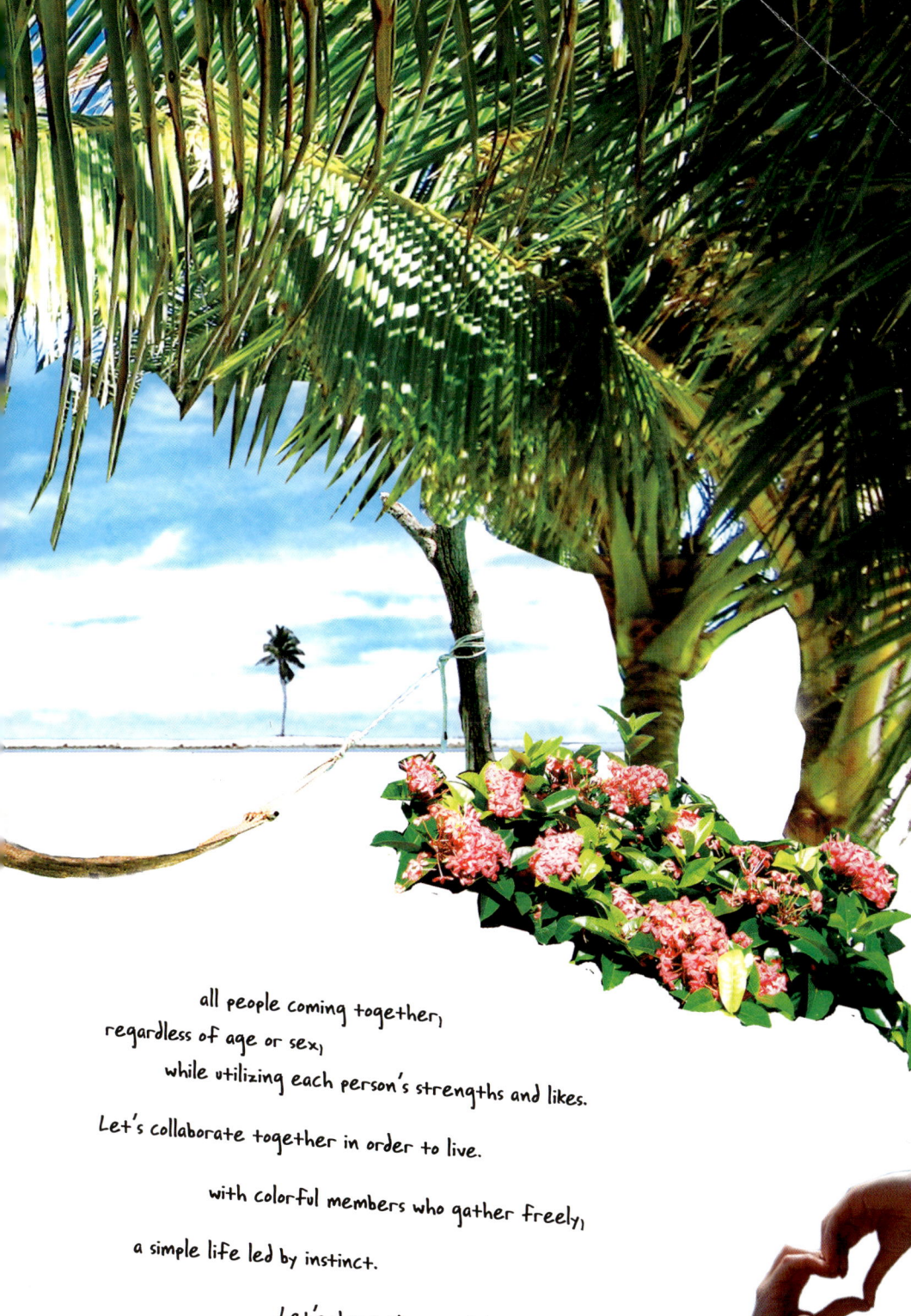

all people coming together,
regardless of age or sex,
while utilizing each person's strengths and likes.

Let's collaborate together in order to live.

with colorful members who gather freely,
a simple life led by instinct.

Let's share the joy of living.

In order for beauty to remain beautiful.

In order for diversity to remain diverse.

strongly, kindly, gracefully.

with the gentle Okinawa breeze blowing, the wild kids laughing.

All right, let's start a legend from here!

YAY! PEACE!

As I was writing away in my notebook—at home, at a neighboring beach, or at my favorite café, I found that I could no longer keep my idea to myself. I picked up my phone and used it to start attacking all kinds of friends.

It ended with something like this...

Cool, right?

Doesn't it sound fun?

My excitement grew even more as I kept explaining it. The others were becoming really hyped as well.

It took no time at all to decide to really do it!

OK, let's go!

Excitement is infinite! Curiosity is infinite too!

And, of course, loans are infinite too?!

But it's all right, it's all right!

There are always other loan companies.

Money comes and goes.

If we do our best, money is sure to follow!

Well, we'll eventually be able to pay it back once this project gets going.

Don't worry, don't worry! It'll work out somehow!

As always, I'm quick to get over such things, they rarely bother me. But, still, I thought extreme poverty might be worrisome, so I asked my wife, Sayaka.

"What do you think? Are you worried?"

"Umm, if it's you, Ayumu, I'm sure it will be fine. I believe in you."

That's Sayaka for you—my amazing wife. We immediately named it the *Island Project* and got started.

Chapter 2: Friends & Hideout

1043

The first part of a great strategy—we need fellow members!

Doing this alone wouldn't be any fun at all, and most importantly, I couldn't hammer a single nail properly by myself.

Hey, wanna build a self-supporting village in Okinawa together?

We will rent some nice property on an island, and try making all the clothing, food, and shelter ourselves. All of this will be from *scratch*.

I've never done this, and I don't know anything about it, but doesn't it sound like fun?

Within a month, two of my old friends joined me in Okinawa. At the same time, a traveling carpenter drifted into Okinawa and joined the group, too.

Okay, we have our friends—the next step's gotta be the hideout!

For starters, we wanted a space where everyone could get together, have strategy meetings, and plot schemes. But an office wasn't really cool. We needed money for the cost of living at hand, so we talked about starting a casual café/bar.

Oh yeah, and with that, let's have a guesthouse too.

We knew that land in Okinawa would be cheap, and that if we all borrowed a little money and did everything by hand, it wouldn't cost that much to start.

OK! Let's do it!

And the four of us began building our hideout.

*Hoping for a nice piece of property somewhere—
a vacant beachside house, with a yard, somewhere cheap…*

I consulted with every realtor on the island, but found no notable property.

Want to try finding it on our own?

Although we wandered the island on our motorcycles, we didn't immediately find any great property. We started to get discouraged, give up a little, and our excitement level dropped.

Sigh. We aren't finding anything. Seriously, I'm tired.

We decided to take a short break and take a trip together. As we passed down a narrow road, we arrived at a mysterious, vacant land… all of a sudden, a terrific piece of property appeared before us.

Island Story 49

WOW! What is this?
Out of the blue!
This is it! This is our hideout!

It was a three-story building with a private beach in Yomitan-son village. It was in the central part of the main island of Okinawa.

Wouldn't it be best if we got to do it here?!
But hey, I wonder if this property is for rent?

It looked unused, but since there was furniture all over the place we figured that someone was probably using it. We knew that even if we could rent it, it would probably be expensive.

Worrying about it won't accomplish anything.
Let's check it out!

We went around to the houses in the neighborhood, respectfully asking if anyone could give us the name of the land and building's owner.
We got the contact information and, excited, I immediately called, and…

As expected, a NO! *Shot down in a second!*

"That property is not for lease." We were told, "It is our recreation facility and it is still in use now. Therefore, we cannot rent it out."

But hey, to be declined at first is a given!

We were sure there was no other property as great as this,
so we decided to be stubborn until we got an OK.
We followed the example of one of our favorite movies,
The Shawshank Redemption. We never gave up!
"Operation Shawshank" began.
I called, submitted documents, invited them out for drinks, sent gifts…racked my brain, changed techniques, changed props, and after eight tries…

We got the OK on the ninth try! YAY!

The rent was set at 300,000 yen a month for everything, including the building, yard, and private beach.

All right! We can do this!

Immediately, we went back to the loan officer, asked friends, and sacrificed savings. Each of us used our own method to scrape together the money we needed. The contract was finalized! We now had the property for our hideout.

wanted!
volunteers

Although we had gotten the property for our hideout, we were still seriously shorthanded on help to build the shop.

But, we don't have any extra money for personnel expenses.
What should we do?
I wonder if there are people, somewhere, who would help for free.

Even though it's probably useless, let's ask!

We created a homepage on the internet and tried to recruit volunteers.

Recruiting volunteers to help us build a hideout!
Wanted: People willing to do hard work in Okinawa in exchange for three meals, a place to sleep, and all-you-can-drink awamori.

Despite such a vague advertisement, we were contacted by many passionate people who wanted to join us—all based simply on feelings. We gathered a few dozen volunteers from around the country, and steadily moved forward in the building of our hideout.

56 Chapter 2

"Ayumu, is there some kind of concept behind this hideout?"
"There isn't a drawing, but in creating this space, do you have some sort of image in mind?"

There were many that would ask such difficult questions, and I would merely answer them with my vision.

I would tell them, "Bob Marley's 'One Love' pouring out at full volume. That's the vibe of the concept!" The rest I entrusted to each of their sensibilities.

The construction progressed. After some time had passed, a hotshot reporter from an architecture magazine called—out of the blue — for an interview.

"This is a really great space. Who is the architectural designer?" he asked. And I replied, "Architectural designer? Hmm, if I must name someone, I'd say Bob Marley's 'One Love' and about a hundred volunteers; we all designed the place."
"Bob Marley? 'One Love'? A hundred volunteers???" The hotshot reporter was dumbstruck.

Hey, what should we name the hideout?

While considering a name, we came across words of fate:
BEACH ROCK.

The mysterious phenomenon of a rock appearing where nothing had existed before, arising from the mixture of various creatures and compositions in the sea—that's the meaning behind these wonderful words. Just like that! Various people gather, everyone's ideas mix together, and one firm rock, a will, is born.

Doesn't that sound cool?
That sounds good!

The decision was instantaneous.

That was a joke.

The truth is, while drinking root beer and chatting with friends at the local A&W burger joint, someone said, **"We love the beach, and we love rock music. How about Beach Rock?"**

March 31, 2001. "Beach Rock House" opened in Yomitan-son village on the main island of Okinawa. It was a café/bar with its own private beach, a beautiful hideout, and a seaside inn.

Island Story 61

YAY! The hideout is open!

With this as our base camp, let's add members, implement strategies for future development, and proceed full speed ahead with the Island Project!

Our excitement was short-lived. There were no signs of customers. The first few months we were open, friends would drop by here and there, but mostly it had become a home for the volunteers and me.

This is bad. There are seriously no customers.

This is bad. There is seriously no money.

We can't pay back our loans if business stays like this.
We are already behind on the rent...
If this keeps up, we'll be evicted! Debt collectors will be after us!
Help!

All right, all right, let's settle down. First of all, customers aren't going to show up on their own without us doing anything, right?

Waiting isn't good. Let's get out there!

And at once, we started a guerrilla advertising campaign.

First, we needed people to know that the shop existed. So we passed out flyers at the airport, tourist spots, department stores, and on the streets. We respectfully asked TV, radio, newspapers, magazines, and every possible media for exposure. We had one "all you can drink for 69 yen!" party after another. We had live performances and talk shows hosting our favorite musicians. We had everything from independent film screenings to game nights, and even a field day. We exhausted every possibility.

We need more friends in the neighborhood.

We went to festivals, the fields, fishing ports, and even tourist attractions in the area saying, "We'll do anything!" and helped out... I helped an old man harvest red potatoes at a nearby field. "Young man, you're too slow. You need to do it faster," he would scold me. We helped an old lady sort sea grapes at a nearby fishing port. "Young man, you're too clumsy. The size is inconsistent," she would scold.

We made friends casually and at the island's laid back pace.

With this outreach and that project, the exchange with the local people began. Gradually word of our hideout spread, and travelers began to gather. Before we knew it, the hideout was overflowing with people, and it started to liven up. I was finally able to put food on the table. Sayaka was happy about that too.

66 Chapter 2

It had become exactly what I had imagined. The hideout was a treasure house of encounters. Those who came to visit got drunk on island liquor and entrusted themselves to island songs. Every time I encountered a strange, interesting, or impressive person, I'd ask, "Wanna build a self-sufficient village with me?"

While I continued to enthusiastically campaign for it, more and more new friends, teachers, and supporters joined in.

In the beginning, I knew nothing, but I turned my attention to studying about Okinawa and self-sufficiency. I learned we needed:

- Someone responsible for lifelines: preparing the facilities for water, electricity, gas.

- Someone responsible for food: agriculture, fishery, stock-raising, and the restaurant.

- Someone responsible for architecture: to build all of the furniture and buildings.

- Someone responsible for leisure: to administrate programs for people to experience Okinawa's culture and leisure.

- Someone responsible for media: to send out information all over the country and the world.

New members joined us, and teams were created. Slowly, we were converting our vision into reality.

Chapter 3: Ocean & Sky

The teams were coming together, and the strategy was becoming visible.

It's about time we start looking for a great piece of land somewhere and create this self-sufficient village!

In search of promising land, we repeatedly traveled the islands of Okinawa.

Island Story 71

ISLAND TRIP

The charm of the Okinawa islands was beyond imagination.

It was really amazing—the old ladies' smiles, some of the world's most magnificent coral reefs, the seven colors of the sunset, the island liquor and song, the forest of sugar cane, the story woven into the legendary Okinawa textile *MINSĀ*...
If we had any free time, we were off to the islands. We became island junkies. Those were the days when we were charmed by the Okinawa light.

Everyone especially loved the summer festivals. Aimlessly strolling the streets at night with Sayaka and friends, surrounded by the transparent ocean, we melted into the atmosphere.

The mystery, mingled with the humidity of the night in the subtropics; the sense of *CHAMPURŪ* (mix together) of all ages and sexes jumbled together; the drums and shouts of *EISĀ* (Okinawa folk dance) echoing in the village; the soft, amiable aura of the villages lined with Ryuku island houses; the absolutely delicious *JŪSHĪ* (seasoned rice dish) and the absolutely terrible awamori with yogurt; the sweat; laughter; the honest eyes of the mischievous brats; and Sayaka's calm expression of enjoyment—these are the pieces of the yin and yang that make up the islands of Okinawa. Call it a bright sadness; call it a gentle strength. I took in this new sense with my entire body. I was enjoying the days in Okinawa.

I continued to travel to the islands of Okinawa, where I would find land that made me think "This is it!" Then I would talk with the owner, research local laws, and draw up the necessary documents.

We should have the land soon!

The *Island Project* was proceeding smoothly.

Island Story 77

Chapter 4: Dead or Alive

While enjoying the Okinawa summer and traveling the islands in search of the right land for the village, I celebrated my 30th birthday.

At the party everyone threw for me at the hideout, I was glad to be able to say with all of my heart, **"It was a completely satisfying 20s."**

Moreover, with great timing, our first baby, the baby that we'd wanted for so long, had formed inside Sayaka's belly!

Strong, kind, and big, like the ocean!

I discussed it with Sayaka, and we named him Umi (海＝Ocean).

I accompianied Sayaka to the OB/GYN appointments, watched the ultrasounds, and listened to his heartbeat. I waited for the birth of our child with so much excitement.

But life has its ups and downs.

Adventure is always waiting for an accident. Three nights before Umi's due date, I was driving home, filled with complete happiness, and **had a huge motorcycle accident.** I was taken straight to the hospital and remained in critical condition and in a coma for a week—to the point that they said my chances of survival were 50/50. While worrying about me, lying dead still in the ICU on the verge of life or death, Sayaka delivered Umi all alone.

I can still imagine the hardship, with her huge belly, struggling through her first delivery, processing police and accident reports. The thought fills me with respect for her even now.

Of course, being hospitalized was hell for me too.

The moment consciousness returned, severe pain attacked my entire body.

Besides pain, I felt anger towards the drunk driver who ran a red light, hit me, and fled the scene. I had fearful thoughts about what I would do if I didn't recover...I was pulled toward such negative feelings. Night after night, my heart was on the verge of giving in.

At night, I was alone. I forced myself to imagine a bright future. I listened to my favorite punk music and watched my favorite movies. With these and other activities, all of the pain vanished.

I am not alone.
When I get home, Sayaka and Umi are waiting for me.
When I get back to the hideout, my friends are waiting for me.
When I get out of the hospital, happy days again with everyone are waiting for me.
I'm a husband, a father, and a leader.
I can't be laid up in here forever.
Quit being so negative. Let's go!

I had become a Super Saiyan of *Dragon Ball*. A series of miracles had happened!
I literally made a miraculous recovery and was released from the hospital in a month.

Island Story 87

After spending a week teetering on the verge of life or death, I returned home. The thoughts and feelings that filled my heart when I held our newborn child overwhelmed me.

Ahh, so warm.

Thank you.

I was grateful toward Sayaka, Umi, my parents, my friends, the doctors and nurses at the hospital—I felt grateful to all of them. But I did not really know, honestly, to whom or what these feelings of gratitude were directed toward. It wasn't limited to someone or something, but more of a transparent sense. It was so intense that I, who was not good at talking about God and spirituality, unconsciously prayed. My tears almost overflowed, and an overwhelming magma of gratitude welled up through my entire body. For a while, I couldn't stop shaking. To this day, that sense of clarity is still at the base of my heart.

Island Story 89

Chapter 5: Heaven & Hell

When the wounds from the accident had healed and life was back to normal, **it was time to revive Ayumu Takahashi and restart the *Island Project*!**

First, we've gotta find land; then start building the self-sufficient village!

We had a new start, and right after I came back, we finally encountered the island we wanted.

The island was Ikemajima. A small, beautiful island, with a population of about two hundred people, located north of Miyakojima.

"That project sounds good. Our island has lots of land. By all means, why not build that self-sufficient village here? And if you guys come, it'd surely wake up the island too. At any rate, come to the island once and take a look. I'll show you around."

Someone visiting our hideout for the first time invited us to come see the island and so we visited Ikemajima for the very first time.

And, we were completely enchanted.
Everything was too beautiful.

Island Story 95

Great!
We've finally found the island we've been looking for!
There's terrific land, too. Let's build our village here!

We met with the administrative personnel and all those who played a key role on the island. We explained the details of our project and submitted documents. The administration formally granted us permission to use the land. The people of the island even provided us with an office/lodge. Everything proceeded surprisingly smoothly.

We are new here, but it's great to meet you!
We promise to do our very best!

We immediately moved to Ikemajima, and went to greet each and every family on the island. Everyone welcomed us. The accident was tough, but God is kind after all!

With no worries, the project moved along smoothly.

But, life has its ups and downs.

Adventure was yet again waiting for an accident. A few weeks after we arrived on the island, the islanders who welcomed us so much, suddenly began to avoid us.

"They're trying to take over the island."

"They have such and such pasts…they are trouble."

It started with anonymous postings on an internet bulletin board full of lies. Then, somebody started posting print outs around the island. Bad rumors about us started to spread rapidly throughout the island. After a while, "We Oppose Island Project" signs started appearing on the island. "Trouble on Ikemajima," the local headlines read. Some islanders gathered at the island's public hall for "Island Project Opposition Meetings."

It had only been one month since we'd moved to Ikemajima. Before we could even do anything, we had become hated on the island.

What? How did this happen?

I was seriously astonished. We came to this island because we were invited, right?
We were granted permission, and we had gone out and greeted everyone.
We haven't done anything yet, let alone anything bad.

Well, it's OK. It's all right.

We're outsiders, and in Okinawa, this is probably something that normally happens.
Let's resolve the misunderstandings one by one.
We mean no harm.
If we keep company with the islanders properly, in time, they'll surely come around.

I thought optimistically at first.

But, the opposition movement toward us didn't settle down. The intensity grew day by day.

Groups of people started to appear. There were even those who came to the office and became violent. It wasn't a joking matter. Some of those who showed up said things like, "If you pay up, we'll leave you alone."

Our troubles were reported by the local television station. There was a series of articles I had been writing for an Okinawa magazine and suddenly, my contract was canceled. All the organizations that had promised to support the *Island Project* drifted away. We couldn't get in touch with most of our Okinawa friends. We even got turned down when trying to rent a house.

It was the first time in my life I'd been ostracized unilaterally ...honestly, it brought me down. The sound of the word *NAICHĀ* (a person from outside of Okinawa prefecture) really stung. The humiliation combined with the frustration that we couldn't overcome this obstacle was really painful.

Of course, if we hadn't made such a big deal of the *Island Project* and said that we were just starting a small, self-sufficient life with family and friends but still started off on a family-scale, we probably wouldn't have had such issues. But we wanted to build a village. If we'd told the islanders lies just to make them happy, or bribed them, we would have been successful. But I didn't believe it was right to say one thing and do another.

"Ayumu, as a leader, that is weak. You aren't alone, and you have many members, right? Even if you have to kiss up, just start it and later, you can do what you want," an older friend advised.
I understood his reasoning, but it went against my beliefs.
The other members understood this and they supported me.
As a result I never surrendered.

104 Chapter 5

We tried everything, but the situation just continued to escalate.
The people of the island began to divide into two groups:
those who were rooting for us and those who were trying
to run us off the island.

They haven't done anything wrong, have they? Besides,
their project will be good for the island.
What can a NAICHĀ possibly do? The island will be taken over!
Get them out!

When I saw the islanders, who had been living peacefully together, beginning to argue with each other because of us, **something ended in my heart.**

Whatever the reason, we are the cause of this feud. This is happening because we came to this island. That is an obvious fact.
I'm sorry.
I didn't come to Okinawa to start such feuds.
Backing down is courageous. We should back down.

Six months after coming to Ikemajima, we sincerely expressed our gratitude to those who had looked after us. We were still unable to even have any real communication with those who didn't understand. Burdened with huge sorrow and unexplainable distress,
we left the island.

Island Story 107

Chapter 6: Love & Hate

We, who had left Ikemajima, held an evaluation meeting and got everything off of our chests. Then we took a grief trip to Bali and let loose. When we returned to the hideout, we had one party after another, regained our spirits, and began our search for new land.

However, the label of "troublemaker," that had already formed within the Okinawa prefecture, **was harder to overcome than I had thought.** We encountered many great islands with the perfect land. There were times when talk would move forward smoothly, but when the Ikemajima issue would be brought up, everything would go downhill. In the end, we would have to give up on pursuing the project on that island…

Scenarios like that were repeated.

All right! Let's do it on this island! This time it'll go well!
I'd picture such a dream, and then it'd be torn away. I'd picture it again, then see it torn away again.

We almost lost tens of millions of yen to people who took advantage of our weakness—people who approached us with sweet promises and dark intentions. My home address was posted on the internet without permission, and strange people harassed us.

I'll kill you if you lay a finger on my family! I seriously lost it and yelled.

For a while, people did whatever they wanted to us. It was craziness.

For a few years after leaving Ikemajima, in search of land to start our village, we repeated the cycle of hope and disappointment, over and over again. Still, we hadn't found the land for our village. We repented everything we should have, and we were doing our best, but...

Maybe it's not possible to continue with the Island Project in Okinawa anymore.

We couldn't bear any more bad experiences in Okinawa. A bad vibe began to drift among the group. **We all loved and hated Okinawa.** We were swaying between the light and shadows of Okinawa. Just mentioning that I was an *Island Project* member almost got me kicked off the community baseball team, and friends who I'd been close to in Okinawa cut off ties with me.

Maybe this is indeed our limit...

I couldn't bear to watch my friends in pain any longer.
I had everyone come together and I made a proposal.

Honestly, it's hard on everyone to continue in Okinawa, isn't it?
It's hard on me too, when I've been beaten down to this point.
I know this is kind of sudden, but why don't we quit trying in Okinawa?
The Island Project doesn't have to be in Okinawa.
There are infinite islands on this Earth.
Let's give up here and leave Okinawa.
Why don't we do this Island Project in some other part of Japan?
Of course, we can do it in Southeast Asia, the Caribbean, or some other foreign island.

Seriously, what do you all think?

Continue on in Okinawa as is, or do it in some other location? Because this was such a serious decision, we decided to take a vote from all the members. And the result of the vote was unanimous: **everyone's heart was still in Okinawa.**

Honestly, it's seriously tough right now, but I don't want to give up.

I came to the Island Project because I love Okinawa. No matter how many years it takes, whatever I have to endure, I absolutely want to go through with it.

Let's quit bad-mouthing Okinawa and the people who oppose us.

If we just grow up a little, I think we'll overcome this someday.

I only see Okinawa…

OK! I understand how everyone feels.

The Island Project is a project for Okinawa, right?

All right then, I've made up my mind.

Frankly, the road is sure to be steep, but let's do our best together in Okinawa!

We decided unanimously to stay in Okinawa. After having seen a lot, the great and bad aspects of this beautiful place, we decided nonetheless to keep on loving Okinawa.

A toast to everyone's will of iron.
To Okinawa that we love and hate!
While converting the anger and pain in our hearts into energy for tomorrow with island liquor and song, we began running at full throttle again.

Then, a new breeze was blowing again.

Island Story 121

I encountered an older man, a self-proclaimed nobleman of self-sufficiency; a funky, old man with long white hair. **His name is Mr. (Mo), 夢, (om), 有, (in), 民), written using the characters** *people*(民)*have*(有)*dream*(夢). Mr. Moomin ran a ranch on the main island of Okinawa and was the owner of a huge piece of land.

122 Chapter 6

If you're going to accumulate loans, pile stones instead! said he, who built his own home by piling stones from around here.

There's no need for a car! There are horses! said he, whose daughter went to high school everyday on horseback. I have to admit, the sight of his daughter waiting at a stoplight on a horse was certainly cool.

And on top of that, when he ate instant cup yakisoba noodles, he'd say "This soup is the good part," and wouldn't throw out the hot water, but drink it all.

We frequented Mr. Moomin's ranch. While helping out with the ranch, learning about agriculture, and forced to ride unruly horses, we came to really like Mr. Moomin. At his house, on the farm, on the road, in the barn, on the horse...we drank and shared our dream with him over and over and over again. Then, one day Mr. Moomin came to me with a mysterious smile.

All right. I understand what you guys are trying to do. I'll help with the issues of the people in the community that you are worried about.
And if it's here, I'm sure it will be fine.

Do you want to use my land and try it out?

I'll lend you all the land that is in my range of vision here for 150,000 yen.

How about it? Wanna try it here?

Oh? Seriously?
We can use all this land? For only 150,000 yen?

The land had a beautiful subtropical forest, a brook, and there were fireflies. It had the best starlit sky, we could see the ocean, and a good breeze blew constantly.

We still had concerns about getting along with the people of the community, but we did decide to do this in Okinawa.

I'm ready.
We gotta take a chance!

Good! This is it!

It had been approximately four years since moving to Okinawa and searching for land in hopes of creating a self-sufficient village. At the end of our long journey, we finally made it to the promised land.

Island Story 129

Chapter 7: Image & Action

Our new village was in the northern part of the main island of Okinawa, in the forest of Yanbaru, we named this place after our favorite *Nausicaä* anime. We called it the *Valley of the Wind*.

While we gazed at this beautiful subtropical forest that we hadn't yet touched, we first created the image of the kind of village we wanted to build!

ISLAND PROJECT / BEACH ROCK VILLAGE

We'll need a cottage so that the people who come to visit have a place to stay.
Let's use sunlight and run this cottage on 100 percent natural energy.
We'll want a café/bar where everyone can get together.
We can make lots of comfortable terrace seats where the nice breeze flows.
Let's build a pizza oven, and use freshly picked vegetables to make the best pizza.
Of course, we have to have a tree house.
Let's build it on top of the tallest tree so that you can see the ocean.
Since there isn't a large area of level land, how about rice and
vegetable fields on slopes?
How about making rice terraces, like Bali's Ubud?
Ah, and we don't want normal tents, right? Something like the Mongolian pao or
a Native American tepee would be nice.
We'll want lots of art studios for everything from ceramics to glass to woodwork.
Let's build an outdoor theater and stage to enjoy the starlit sky and moonlight.
Listening to a live performance in a place like this, with the fireflies dancing,
would be way too cool.
And yeah, maybe we should get an elephant…because an elephant is
a symbol of peace.
And oh, this being the Valley of the Wind, we gotta have Nausicaä's mehve, right?
We can't make the gunship by hand, but we can build the mehve!

We added this…and that…

We had nothing yet. We walked around the desolate property, opened the wings of our imagination, and flew about the skies of fantasy. Thinking about whether it could be done or could wait for later.

First, get rid of all the stereotypes in your head, and let's picture it as freely as possible!
Hey, if you could do anything, what would you do?
If we could build Disneyland on our own, how would you build it?

With such conversations, we completed a wonderful image map.

Beach Rock Village
mountain area

Island Story 137

Together, we confirmed the journey by completing this village, everyone's roles, and the rules to be followed. The ideas and images, which were floating like vapor until now, became a drawing, became words, and took on a solid form with an organized outline. What it was we were aiming for; what it was we were creating. While sharing and planning with all the members, a vivid power came gushing out.

All right, now all we have to do is make it a reality!
Let's do it! Let's create the best paradise in history!
Let the Tom Sawyer in your hearts go wild!

All right! First, it's pulling weeds!
We gotta flatten this wilderness, or we can't build anything!
Come on, all you volunteers!

With a human wave of passionate volunteers, both the old-timers of the hideout-building days and new participants, the ground was leveled in no time.

Next, the lifelines of water and electricity.

Following the teachings of the landowner, Mr. Moomin, we drew water from a creek a few dozen meters away. We put a water tank on the back of the truck and went to draw water wherever we could. For drainage, paying attention to the details, we used a compost toilet so that the water would be reused for agriculture, and we built a system to purify the water to the point we could keep fish.

For electricity, I met a Che Guevara-loving eco-craftsman, and we hit it off. With his navigation and discount, a solar energy system was introduced.

About the time the lifelines were finally in order, the book royalties that were supporting my family's living expenses had begun to run out.

We're in trouble. We have water and electricity, but we don't have the essential money!

We needed to pay the rent for the land every month and we needed to buy tools and supplies to build the buildings. After that, there were expenses for running the agriculture and fishery. A little more cash was needed for phone bills, CDs, gas, and even for dates. A little cash was needed for the members to be able to live…

This is bad. If this keeps up, we'll end up as primitive men!
The primitive men of Okinawa? This isn't a laughing matter!
I have a child!
Ayumu Takahashi is off to raise funds!

In order to build the village, I began full-fledged fundraising. I ran all over Japan, meeting with people of every kind, submitting documents, passionately explaining, and asking for support.

*Self-sufficiency is good, but it won't be profitable. Sorry, but I can't help you.
Is this the proposal? An amateur group? No collateral?
There's nothing to discuss.
After you've traveled the world, how could you ask for money?*

*Umm...true, you're exactly right...I apologize. But if I don't get this money together, this project will be discontinued, so...it's not a matter of if I can or can't.
I have to do this!
Let's go!*

I hit up everyone, from banks to friends. And in the end, with the support of some thoughtful people, I was somehow able to gather minimal funding. I was very grateful.

Work finally began peacefully on the main building, the cottage. But we had absolutely no room in the budget to buy luxurious wood. So instead, we went to the neighboring beaches in search of cool driftwood, we helped demolition workers and brought back window frames, and we went to help an old man in his forest and brought back thinning wood.

We would shout together...

If there's no money, then use your head!
It you're not smart, then use your body!
Yes. We take pride in our physical strength!

With island liquor as our gasoline and the island song as our cheer, we did it all, from the stocking of materials to construction work. And we did it all on our own. Without spending money, we utilized the blessings of nature. We had a first-class, authorized architect friend to help us with the legal regulations. A handmade and order-made, fantastic cottage was completed.

Island Story 147

OK. The café/bar is next!

But putting down the foundation and getting the building materials will cost money, and that's not possible.

What would look cool, be cheap to build, be comfortable, and be able to withstand typhoons?

Oh, yeah! A tent! Tent!

Not a small one, but a huge one that a few dozen people can fit into.

With a tent, it can be easily taken down and put away for typhoons.

Let's create our own original gigantic tent using the world's ethnic tents as an example!

That's when we developed our original giant tent, "Tipa," by combining the structures of the Native American tepee and the Mongolian nomad pao.

The world's ethnicity is good, but we gotta add some Okinawa flavor to it!

So, we built a circular bar counter with the Okinawa word *YUIMĀRU*, meaning "mutual aid," in mind. We stocked the café/bar with all of the island liquors from the 47 distilleries of Okinawa, great beer from around the world, organic coffee, macrobiotic food, and our own original pizza oven.

Preparations for opening were well under way.

150 Chapter 7

Working on the cottage and café/bar is good, but the pillar of self-sufficiency has to be agriculture! If there's nothing to eat, everyone will starve to death!

So, at the same time, we began cultivating the agricultural land. We started as complete beginners, but our teachers gave us tons of advice. We overcame one failure after another, and all worked hard together under the motto, **"Full swing again today! Slide headfirst into home!"**

Little by little, the vegetables and rice we grew began to make their way to the dining table. As might be expected, "fresh from the farm" far exceeded "shipped direct from producer." The vegetables had a whole new dimension of taste.

"Were vegetables always this delicious?" I was so surprised and impressed. I've seriously fallen in love with vegetables.

We spent our days getting muddy and sweaty under the sun. The beer we downed on our empty stomachs was indeed HEAVEN.

Instead of just vegetables and rice, you want to eat meat, too?
Well then, please slaughter the animals yourselves.

So I tried killing a chicken for the first time ever. It was really hard. In the end, I couldn't do it.

I'm the gentle type, so I'm not any good at this sort of thing…

But that excuse meant absolutely nothing, and everyone looked at me with contempt.
I went back and, after actually doing it, I felt gravity center on the words "to have food (life)." In the moment of killing, a simple and dignified atmosphere flowed. It's easy to say, "Sense the circle of life through experiencing the process of life and death," but self-sufficiency isn't easy after all. That brought me down a little.

We want to share with you the pleasure and pain of self-sufficiency!

We decided to hold a "Self-sufficient Experience Camp." It began with a five-night/six-day camp to experience self-sufficiency in food, clothing, and shelter.

Wonder if anyone's interested in self-sufficiency?
What'll we do if there aren't any participants?
Well, let's just give it a shot!

This camp, which we were skeptical of in the beginning, was unexpectedly very popular. It astonished us.

With "Increase Vitality" as the theme, and through trial and error, we created many encounters and dramas using everything from "Close Encounters of the Third Kind in Nature" to *Dating Game*–type scenarios. Dozens of people came to participate every month, and the operation was gaining in popularity.

We're busy everyday with tons to get done, but we need to have fun too! No play, no work! Those who do not play can't be transmitters of play!

We spent our spare time heading off to the beach, the mountains, and the river.

We did everything from plunging into the ocean; trekking the subtropical river where beautiful rainbows hung; diving and marine sports with friends; experiencing folk crafts, such as indigo dyeing, ceramics, glass, and textiles; to let's-visit-the-old-lady's-home tours.

While we were adventurous and enjoying Okinawa, many interesting leisure plans were born.

Island Story 157

Island Story 159

We won't repeat our mistakes anymore.

Each of us utilized everything we had learned from our experiences. By accumulating and using those experiences, good relations with the locals were built. Our hometowns, dialects, ages, and history were all different, but all people are connected at the roots. While having honest conversations with each other and utilizing each other's strengths, our energies began to revolve smoothly. I was so happy to see that the painful experiences we had undergone were actually useful. "I'm so glad we didn't give up on Okinawa" was a thought I kept expressing from the bottom of my heart.

Island Story 161

Now, the cottage is completed.
The café/bar where everyone can have fun is completed.
The "fun plans" are becoming substantial.
I think it's OK to have customers soon.
Our village will finally be open!

In that air of excitement, we decided to close down the "Beach Rock House" hideout for the village.

What a waste! It's thriving so much. Why?
I like this place, so please continue!

I was glad to hear so many people speak up against closing it down.

Of course, I was sad, too, that the hideout would no longer exist, but we had decided from the very beginning to close down the hideout once the building of the village began.

If I succeed, without protecting, I immediately destroy it.

That is my aesthetics.

Of course we needed money, but if we kept relying on the profits of the hideout, the village would never get off the ground.

Gracefully tear down whatever is successful and begin the challenge again from zero; that is what allows us to build something new.
Just laugh with ease at the poor state in front of you, and let's aim for higher and keep moving forward.
The era of "Beach Rock House" is over.
The era of "Beach Rock Village" has begun.
From a house to a village, the Beach Rock continues to evolve.

On March 31, 2006, "Beach Rock Village," a self-sufficient village overflowing with music and art, opened!

The stars in the heavens were shining down on *The Valley of the Wind*.
Everyone was truly laughing from their hearts. Though it was small,
it was a very passionate opening party. I was there with my wife,
Sayaka, who always cheered me on; my three-year-old son, Umi,
who had been raised listening to the Stones; and our newest family
member, our daughter, Sora (空＝SKY), a baby with clear eyes like
those of Nausicaä; everyone came and was happy for us. I was happy.
Surrounded by my dearest friends and family, I got drunk
with friends, and I celebrated the opening of the village with joy.

Chapter 8: Zero to One

At the same time as the village opening,
we made an important decision.

My role is always to go from *zero* to *one*.

I decided that once the village was up and running, with a stable foundation of management and systems established, I would hand over the role of director and management to an applicant. I would leave the village, and most likely return to being a traveler. The exact time frame for this plan was approximately two years. I hoped to do my best with everyone for two years to bring this place from *zero* to *one*, and then hand over the role of director to someone else. With that said, "Anyone interested in being the second-generation director?"

I'll do it. I plan on staying in Okinawa until I'm buried here.

The second-generation director was chosen. We settled on the acting site leader, Aki.
And the other members were free to choose their future plans. They were given the option to stay and continue, or leave. We gave them some time to think about it.

But, for these two years, let's do our best to achieve one from zero and aim for the perfect last scene together!

The Island Project Establishment Era, the period to create one from zero, will end in two years.
The existing team will break up on the day of the second anniversary of the village opening.
From there, it will be the new director and his new team.

With the time limit fixed, a pungent tension was born amongst the members.
We weren't the slow-life type to begin with, but with a concrete time axis and goal, we began to realistically calculate backwards and sped things up even more. In two more years, the village would evolve, in every aspect of clothing, food, and shelter, from *zero* to *one*. Days were filled with making the overflowing images into a reality. Our dreams, like surging waves, began to become a reality.

LET'S GO!
TO THE NEXT STAGE!

First, the tree house.

Leaving out a secret fort made in the trees was not an option for us, being people who love Tom Sawyer and *Stand by Me*. The moment I thought I wanted a tree house, a face came to mind, and I knew it had to be the world's best tree-house creator, Takashi Kobayashi. I went to visit Mr. Kobayashi's shop in Harajuku, and while grabbing a bite to eat together, I expressed our ideas. After he had a look at the forests of our village in Okinawa, he concluded...

OK. I guess I'll do it! If it's here, we could create something extraordinary; something never seen before. Oh, by the way, I don't like Tom Sawyer," Mr. Kobayashi said, and took on the project willingly.

Led by Mr. Kobayashi's team, with the village members helping, the construction of the tree house began on a giant Ryukyu hackberry tree. It was eighteen meters above ground, the equivalent height of a six-story building. **Indeed, a castle in the heavens.**

The top with the design pictured onto the linen by arranging raster color, the colorful tiles that give off a prismatic shine, the feel of the handrails made from streamlined driftwood, and the thrill of "If I slip and fall here, I'd die, right?"—all of it was beautiful and went against all common sense.

Respect for freedom, playfulness, adventure, art, nature...
As if to symbolize the thought that we poured into the village, the best tree house in history was completed.

176 Chapter 8

We had a party to commemorate the completion of the tree house. After a performance by Keison, the musician who rushed over for the celebration, we all shared a minute of silence...silent, quiet time to feel the wind of the tree house. Taking in the star-filled sky, the floating dance of fireflies, the lit-up tree house, the harmony the insects play; my son, Umi, muttering, "Dad, this feels good"...
it was a very memorable moment.

Island Story 179

It was impressive when a typhoon hit the village. When we were initially deciding which tree to build on, we debated whether to place emphasis on anti-typhoon measures and safety and build on a low, average tree, or build on the strongest huge Ryukyu hackberry tree. We were pressed with an ultimate choice, but decided on the bigger risk. We originally started this with a sense of fun, so playing the defense would be boring.

If a typhoon comes and it scatters, then it scatters. It's OK!
Like cherry blossoms, that vanity is beautiful, too.
If we're going to do this, we might as well create the best tree house in history on the strongest tree!

We discussed it with Mr. Kobayashi and chose the Ryukyu hackberry tree. Not long after, a large-scale typhoon hit us directly. Right after it passed through, at daybreak, I fearfully peered up at the tree house…

No way! It survived magnificently! WOW!

"The wind and the rain and the forest and the tree house…I built it imagining none of those clashing into another, but with the image of them all living together. But, honestly, when I heard that the typhoon was going to hit directly, I was worried what would happen if it was destroyed," Mr. Kobayashi said grinning.

Island Story 181

The Valley of the Wind is great, but we want the beach, too, right?!

And so, the let's-make-a-beach-house plan got started. Near the village, at a cape of the northern part of the main island of Okinawa, we discovered a quiet beachside property with the best sunsets! Immediately, we started negotiating with the landowner, but...

Would you rent this property to us?
No. Never. I'm 100 percent sure I don't want to rent it out, so give up.

And as always, it was the same difficult scenario.

Again, a NO right off the bat...but we'll be stubborn!

With a *keep-it-up-until-it-goes-right* mindset, we continued the negotiations. Over and over again, we visited the landowner's office and helped out with his work. While drinking and passionately explaining, he gradually began to understand...and in the end we were successful in renting the property!

A seaside fort was completed at this wonderful beach full of privacy. It had a hammock, a place where we could enjoy barbecues, and had lodging!

If the secret fort is complete, don't we need a pirate ship, too?

And so, the strategy to acquire a pirate ship began! We had a difficult time trying to find a cheap ship, but after some time, a fisherman we knew was willing to give us a small ship.

We have our pirate ship!
All right. This makes us One Piece (manga)!
I am Captain Luffy of the Straw Hat Pirates!

The Valley of the Wind surrounded by the subtropical forest and *Cape One Piece* surrounded by the beautiful ocean, Beach Rock Village was now able to enjoy both the ocean and mountains of Okinawa.

Island Story 185

Island Story 187

Of course it wasn't always smooth sailing. Customers weren't just going to show up to see a strange, unexplored area on the outskirts of Okinawa.

If we create a marvelous space, geographical convenience shouldn't matter. Soon enough, it will be overflowing with people.
Let's believe and move forward! If we keep our spirits up,
anything is possible!

While telling ourselves such things, we kept the action going, but we weren't readily getting results. "Clothing, food, shelter and energy at this self-sufficient Village!" we'd say, but after all, we were just an amateur group. Many things didn't go smoothly and I was often discouraged. Those of us who were originally big city kids found it hard to protect ourselves from the harshness of nature: typhoons, landslides, blackouts, floods, water supply shut-offs, and dangerous creatures and plants. There were troubles almost every day.

There aren't any customers, and we argue with each other all the time. We have a place to sleep and food to eat, but we have no money. Nature is nice, but we miss the city...

About a year after we opened, everyone was hit with homesickness. The village management wasn't going very well. The members were constantly arguing with each other, and the atmosphere of the village was gradually getting worse. Then, one by one, the members who had worked hard together from the early days of the village, began to quit. Our optimistic group began to lose the challenging spirit and a negative vibe began blowing through the *Island Project*.

190 Chapter 8

Island Story 191

Y'know, lately, aren't we pathetic?
It's a given that things don't go well from the very beginning.
No matter how awful, no matter how difficult, continuing to challenge yourself more is the very thing that makes you grow as a person and opens up the future!
Didn't we decide to do our best together even if it kills us and accomplish zero to one in the two years after opening?
Now, seriously, make up your mind.
No matter how bad it gets, let's finish this!
Without running away, let's stick with it.

Together, our efforts recombined.

We drank, talked, puked, and drank again, talked—once again, we went back to the basics. Together, we had one intense drink after another. We bared our souls to each other and made up our minds. And then we swore to move forward once again.

We only have one more year left.
We are moving toward that goal we set.
Let's work our way closer, step by step!
Come on, for the last year, let's give it all we've got!

Our slogan...

Aim for 100 percent self-sufficiency!
We won't shop at the supermarket vegetable section anymore!
The self-sufficiency ratio of agriculture in the village rose rapidly. We were providing approximately 100 percent of the vegetables for ourselves.

The rice fields. We borrowed an idle farm near the village and experienced the cycle from planting to harvesting. Now, all we needed was to enlarge the space.

Since we're going to plant the rice fields anyway, let's do it funky!

And so, we brought in sound, lights, and a disco ball, changed the field into a club for only one night, and held an event to plant the fields while dancing. "Farm Rock Night!" was a great hit.

My friend, USA, the dance performer from the famous group EXILE, joined us. Grown people were muddy from head to toe, and danced, played, and worked. It felt so good.

For beautiful things to remain beautiful, let's do something; something that we can do, for the beaches of Okinawa.

From that idea, we started the "Blue Lagoon Festival." The event was set up as a charity and steadily grew as it was repeated. In the beginning, this festival was very much in the red, and there were difficult times.

What is charity? What is contribution? What is environmental protection?

We strained too much and almost made things complicated, but gradually, we began to relax in a good way. It grew into a wonderful festival with a steady atmosphere of the love for Okinawa, and the love for nature.

Island Story 197

We steadily increased the number of our tents, the "Tipa," and added new arrangements. Various terrace seating was created around the café/bar so that the great outdoors could be enjoyed to the fullest. The outdoor theater and stage under the starlit sky was completed, and many great performances took place within the village.
A neat art studio that would have surprised even Gaudi was completed using compressed straw.

We had an electric-generating device that worked with a bicycle, a seriously scary trapeze, and a wonderful car that ran on waste oil so that the cost of gas was zero. We painted a funky wagon and called it the "Beach Rock Machine." The punk *Blue Hearts Awamori*, our own version of this alcoholic beverage matures while Blue Hearts (a Japanese punk band) songs are played 24/7 for three years. These fun dreams became a reality, one after another. Regretfully, the elephant and the *mehve* hadn't come to fruition yet, but just about all of the image map pictured in the beginning had become a reality.

ZOO Chapter 8

The media began coverage on the village, even some of those that avoided us in the beginning. We heard from reporters who responded to our first requests by saying, "A hippie village? Too weird!" In the end, magazines, newspapers, and television coverage requests were pouring in from around the country.

We were astounded and asking, "Huh? What happened? Why?" while Beach Rock Village leaped into fame!

Yes! Finally! Knocked it out of the park!

Travelers gathered from all over Japan and the world at our unique eco-village. People came to see our café/bar and inn in nature that Okinawa-loving young kids created. Many people—the locals, of course, people from all over Japan and the world, people with their families, as couples, and travelers—came to visit and it grew into an even better *"Delicious! Fun! Feels great!"* space than we had imagined.

With almost two years passing since its opening, with the management change and existing member break-up before us, the village that had begun from absolute *zero*—even in the visible sense of buildings and finances, and in the invisible sense of reputation and atmosphere—finally arrived at the stage of *one* we had aimed for together. Now, even though the central members from the establishing days were no longer here, with the power that the village had and the power of the new members, Beach Rock was destined to never stop growing! Feeling and believing that in my heart, I was finished with my duty of *ZERO to ONE*.

Island Story 203

Chapter 9: Hello & Good-bye

For the ending, we should take a journey together.
For all the people around the country that supported us until now,
let's go tell them, "Thank you! And don't forget us!"

With our break-up approaching in three months, we all climbed into the wagon and took off on our final journey.

A trip around Japan to all 47 prefectures, a party tour!

While traveling to and partying at each and every prefecture, we drank island liquor and sang island songs together with about ten thousand people.

Japan is absolutely wonderful.
I hope we can work even harder to be proud that we were born in this country.
Let's each keep running on our respective paths from here, but in the near future, let's come together and do something gigantic!

I was able to exchange such feelings with many people.
It was absolutely an ardent journey.

We made our way around 46 prefectures, leaving Okinawa for last.

Together, let's go pay our final respects!

We went around to all the memorable islands, including Ikemajima. The Okinawa islands that we hadn't visited in a long time were still glorious. We reunited with people who never gave up on us and supported us to the end during the opposition movement. Good old posset, drinking round after round, with passionate talk.

You did it after all! You guys weren't wrong!

Together we downed our island liquor, and together we cried like babies.

The heartaches we suffered several years ago on the islands
of Okinawa had completely changed into beautiful memories.

Island Story 207

Island Story 211

Then the day of the second-year anniversary of *Beach Rock Village* arrived. The final party began at the village. It was my last night as the director of the *Island Project*. All this time, I worked hard, keeping the image of this day in my head.

It was an image of me in this great village that we created and built, under the starlit sky, with tons of customers, surrounded by wonderful members, listening to beautiful music, and with a nice breeze. That scene was now a reality.

Wow. Déjà vu of happiness!

Enveloped in a moving atmosphere, watching the tear-filled expressions of my friends, I suddenly thought, "These guys are the absolute best."

Then, together with the members, I got on stage to give my final farewell.

From the very beginning to the very end, there were so many things that didn't go as planned. There were infinite times when we just wanted to run away. But none of the members gave up. We said, "Let's be sure that in the end, we'll be able to respect each other," and worked hard together…
And right now, I respect these members from the bottom of my heart.

Thank you so much for everything! Please keep Beach Rock Village alive forever!

The singing voices of Simap, the band that the members of the *Island Project* created, echoed into the night sky forever and ever.

"Go For It" by Simap
Whatcha doing now? You always ask so...
I'm doing what I love! I'm gonna answer.
Whatcha gonna do now? You always ask so...
I'm gonna do what I love! I'm gonna answer.

Making a dream a reality seems really difficult,
If you keep going as long as you can certainly you can do it!

Go for it. We aren't finished yet.
Go for it. Let's keep chasing the dream.

We are the seven colors like that rainbow,
That bridge, the sky, and ocean, like that rainbow.
We aren't all the same color, shining our own color.
OK, hold hands and be happy together!

Go for it. We aren't finished yet.
Go for it. Let's keep chasing the dream.

The path we take is a steep road
But when you run to the end it feels so good!

Go for it. We aren't finished yet.
Go for it, this is where it all begins.

OK, lastly, the best beer fight in history!
A few thousand bottles of Orion Beer piled high and a beer tower was completed!
Great job, everyone!
Thank you so much!
Tonight, let's swim in a sea of beer!
A toast...to a wonderful night!

It was the first time ever that I saw a waterfall of beer. It was the first time that beer had soaked into my skin. Suddenly, I looked up at the sky. The lights reflecting onto the mist of the scattered beer had created lots and lots of tiny, round rainbows.

Yeah. This is it—the rainbow-colored YUIMĀRU (collaboration). Great!

Then, at the end of the night, there was quiet. The entire staff who had worked hard on this project gathered together; a time for our good-bye ceremony with just the members. We sat around the campfire in a circle. Each person said a few words. We gave each other our last words. The members all shared, including myself, members who were parting from this village the next day, and the members who were remaining at the village the next day, we were savoring the last bit of time we had together, each overlapping their story with others'.

220 Chapter 9

Island Story 221

Not just a limited number of people playing an active role, but everyone did their best in their various positions, producing results that were respectable with each other.

"We did it. We're a good team," we said, smiling in the end. That really made me happy.

Island Story 223

It was not a unity like that of squashing everything together, but independent individuals shining through to create a collective energy. It was a unity like that of being connected at the roots, in that space at the end of the end. There was that kind of a feeling drifting in the air. It felt so nice.

Island Story 225

I'm sure that each and every person who participated had different feelings about the *Island Project,* but at the heart, I think all we wanted was to put our strength together and feel "the joy of living." We wanted to feel a "Mom, thank you so much for giving me life" type of happiness, which is what is at the core of all the difficult and sad situations.

Island Story 227

Okinawa is wonderful.
Nature is wonderful.
Friends are wonderful.
Life is really wonderful!

Island Story 229

Thanks.
We love you!

With the gentle Okinawa breeze blowing, the wild kids were laughing.

Island Story 231

On March 31, 2008, after almost eight years, my *Island Project* days had ended.

Island Story 233

Island Story 235

epilogue

238 Epilogue

Several months after we, the initial members, left *Beach Rock Village,* with Aki, the new director, and the full-swing boy Keisuke as the new leader, Beach Rock Village is in its second stage and doing better and better. Of course, all the members who left the village are also doing great. Some took off on journeys, started new jobs, got married...each one has started strolling along on their own path.

When we were together, living under the same roof, during fun times, hard times, and drunken times, there was a slogan we had: "Beach Rock keeps on growing!"

Island Story 241

No matter how big it gets,
no matter how much praise it receives,
never forget the feelings of love for each and every one.

Island Story 243

*Let's each keep going
in each path, infinitely.*

Island Story 245

Stay a small fish, forever.
Let's keep challenging new things!

Island Story 247

248 Epilogue

Island Story 249

Note from the Author

After the *Island Project* was over, summer was here again and I turned 36. With a big sense of accomplishment, a new hope, and a little bit of loneliness in my heart, I was enjoying the last summer I would live in Okinawa.

After the world journey with my wife, Sayaka, we moved to Okinawa at 28. It had been eight years since then. I spent my late 20s and early 30s here in Okinawa. And now, I feel from the bottom of my heart that it was the best time. I was happy.

The fact that my kids, Umi and Sora, were born in Okinawa is important. Being able to spend their childhood on this island will be a big asset to them. For them, they will always be "born in Okinawa."

To all public and private people who supported us, people who fought with us, everyone included, I can say this from my heart: I am grateful to everyone I had contact with. Thank you so very much.

November 23, 2008, celebrating our ten-year wedding anniversary, I departed again on a world journey with my entire family. No plans on how long or to where, but just to travel in any which way our hearts desire. And after that, we don't know where we will live.

Until the day I die, I only have to live to the fullest this life I was given by my mother and father, Keiko and Gen Takahashi, together with my wife Sayaka, my children, Umi and Sora, and many friends.

If life is 80 years, then I have 44 years left.
I'm not even halfway. The fun hasn't even begun yet!

DON'T STOP!
The journey never ends.

September 5, 2008
At my beloved home in Okinawa.

Island Story 251

STAFF
ISLAND PROJECT 2001/3/31–2008/3/31

Ayumu Takahashi
Daisuke Tsuchihashi
Yasuhide Waku
Jun Sudo
Shinichi Sugai
Yuichi Okuhara
Kouichi Iijima
Keiko Nagatsu
Nami Matsuno
Tomohiro Yoshida
Akari Tachibana
Yasumasa Tengan
Hiroko Tokudome
Minoru Takahashi
Akihito Arai
Makiko Kokubu
Yukiyou Kamiyama
Takayuki Sato
Miwa Yakena

Your Name He[re]

- Susumu Yamashiro
- Chinatsu Ogiso
- Akira Nihei
- Yukihiro Mukouyama
- Hitoshi Komiya
- Ikumi Ito
- Seinosuke Kumakura
- Miki Kawachi
- Masumi Yoden
- Hirobumi Ishiyama
- Keisuke Kawamura
- Noriaki Furuya
- Keishi Oishi
- Satoshi Kimura
- Maki Saito
- Naoki Hasegawa
- Ikuko Nishimura
- Fumihiro Asano
- Hironori Nakagawa

BEACH ROCK VILLAGE
NATURE, ART, ADVENTURE WITH LOVE & FREE

In the middle of the nature in Okinawa.
The nature village where you can enjoy **great food**, **fun**, and a **relaxed time**.

To the mountains and beaches.
Beach Rock Village welcomes you with full of **music**, **adventure**, and **art**.

Let's share the pleasure of living the earth!

For enquiries, contact below
BEACH ROCK VILLAGE
Tel: +810-980-56-1126 (during 8 AM–8 PM Japan time)
URL: http://www.shimapro.com/ (Japanese Only)
Email: info@shimapro.com
Address: 1331 Shana Nakijin Mura Kunigami Gun Okinawa, Japan 905-0414

"LOVE&FREE"

A best-selling novel in Japan
with more than 240,000 copies sold, and now available worldwide!

Full color, and totally redesigned using new photographs taken from the streets around the world!

KEEP BLUE SKY IN THE HEART.
BLUE SKIES ARE CONNECTED.

- journey1 : to Australia -

You Choose Everything!
Be true to the voice in your heart.

- journey final : to Japan -

LOVE & FREE
NEW YORK EDITION BY AYUMU TAKAHASHI
WORDS & PHOTOS collected from the streets around the world

Wanna roam the world?
From the NORTH POLE to the SOUTH POLE and everywhere in between!!
The RECORD of an adventurous journey, roaming the world on their honeymoon for 2 YEARS by an average, but a bit POP Japanese couple.
One Peace Books Inc.

LOVE&FREE
Messages collected from the streets around the world
WORDS & PHOTOS AYUMU TAKAHASHI
Published by One Peace Books Inc. / ISBN978-0-9785084-7-0

Wanna roam the world?
A travelogue of a two-years-around-the-world journey with his wife to numerous countries between the South Pole to the North Pole.

If you read this book, you will want to cross the sea and go on a journey yourself.